THE MIRA

Lin Coghlan

THE MIRACLE

OBERON BOOKS
LONDON

First published in 2008 by Oberon Books Ltd
521 Caledonian Road, London N7 9RH
Tel: +44 (0) 20 7607 3637 / Fax: +44 (0) 20 7607 3629
e-mail: info@oberonbooks.com
www.oberonbooks.com

A catalogue record for this book is available from the British Library.

PB ISBN: 978-1-84002-841-6
E ISBN: 978-1-84943-950-3

Cover design by © Randy Faris / CORBIS

Printed and bound by Marston Book Services Limited.

Visit www.oberonbooks.com to read more about all our books and to buy them. You will also find features, author interviews and news of any author events, and you can sign up for e-newsletters so that you're always first to hear about our new releases.

For Olga Maginsky
Writer

Characters

RON 12

ZELDA Ron's best friend, 13

MRS SHEEHAN Ron's mum

GINGER Zelda's dad

MRS GINGER Zelda's mum

TROUSERS Ginger's best mate

ANGELA BRICKMAN 17

MRS BRICKMAN Angela's mum

BARRY O'DONNELL 15

MISS LOWERY Head of School

LORENZO HAMMOND
A soldier returning from the Iraq war

BILLY HAMMOND
Lorenzo's younger brother, 12, mildly autistic

HEADER HAMMOND Lorenzo's dad

MRS HAMMOND

PETER 'CHEWY' ZAPADSKI 10

ELENA ZAPADSKI Chewy's Mum

MR RODGERS A teacher, long dead

ROSIE, RONDA, RENATA-MAY The Lanky Girls

LUCY CUMMINGS 16

GRAN

PC 703

MAXIMUS DECIMUS A lost dog

Plus some brief appearances by others

The Miracle was first performed in the Cottesloe Theatre of the National Theatre on 16 February 2008 with the following cast:

RON, Ruby Bentall

ZELDA, Rebecca Cooper

MRS SHEEHAN, Clare Burt

GINGER, Paul Thornley

MRS GINGER, Kellie Shirley

TROUSERS, Gregg Chillin

ANGELA BRICKMAN, Claire Foy

MRS BRICKMAN, Nicole Charles

BARRY O'DONNELL, Benjamin Smith

MISS LOWERY, Petra Letang

LORENZO HAMMOND, Henry Lloyd-Hughes

BILLY HAMMOND, Ryan Sampson

HEADER HAMMOND, Jack Gordon

PETER CHEWY ZAPADSKI, Ian Bonar

MR RODGERS, Sam Crane

THE LANKY GIRLS, Nicole Charles, Claire Lams, Kellie Shirley

PC 703, Troy Glasgow

All other parts were played by members of the Company

Director Paul Miller
Designer Simon Daw
Lighting Designer Paule Constable
Sound Designer Rich Walsh
Associate Video Designer Paul Kenah

This play was commissioned by NT Education as part of its Connections project.

A town, somewhere in the British Isles.

Night.

The population of the town stands looking across the rooftops, as if remembering.

The rain cascades onto pavements, shopfronts and guttering.

RON and ZELDA stand amongst the throng.

RON has a pineapple in her hand.

ZELDA: No one believed us, said we was making it all up, but we never. Int that right Ron?

RON: Yeah.

ZELDA: We never. It all happened just like we said, that weird week.

RON: Freak they said it was.

ZELDA: That storm.

RON: Rain come down, what was it like Zel?

ZELDA: Ain't never seen nothing like it. Wasn't long after that we had the miracle.

RON: Come up through me floor, right next to the bunk beds.

BILLY: You hear that Mum? I heard something – next door.

RON: Heard it next door they did.

ZELDA: Billy Hammond heard it when he was in the bath, said he heard voices, come up through the plughole.

RON: But he was having us on…

ZELDA: I mean, why would Billy Hammond get a miracle up his plughole?

RON: And you don't get two miracles in one night, do you?

ZELDA: Don't make sense. Me mum, she never believed Billy Hammond, said he was just having us on…

RON: But my mum said maybe miracles can all come together, like buses…

ZELDA: But miracles and buses – they ain't the same thing, are they Ron?

RON: No, they ain't the same thing. Course not. And not long after that, I got me special powers. And I started helping people – least I could do.

RON and ZELDA meet ANGELA BRICKMAN, 17.

How can I help you?

ANGELA: Dunno. I just feel terrible like, right…depressed.

RON: Don't tell me no more.

ZELDA: Best if she uses her powers – to scan you.

ANGELA waits nervously while she's 'scanned'.

RON: Tongue?

ANGELA sticks her tongue out.

ZELDA: Picked up something straightaway she did.

ANGELA: (*Anxious.*) What is it? What d'you see?

RON: You feel your heart sometimes?

ANGELA: Yeah. I do.

RON: Appetite?

ZELDA: Thin as a rake she was.

ANGELA: Can't seem to taste nothing.

RON: Thought as much. You want to eat a pineapple, one a day, if you can manage it.

ANGELA: Pineapple?

RON: Come back in a week.

ZELDA: That was the first time she helped someone, and it just went on from there. Course, not everyone saw it Ron's way, not at first like.

MRS BRICKMAN: Pineapple? But you hate pineapple.

ANGELA: Leave me alone Mum.

MRS BRICKMAN: I don't know what's the matter with you. Is it that boy?

ANGELA: I'm just taking my pineapple up to my room.

MRS BRICKMAN: Taking yourself so seriously. Don't be silly. There'll be other boys. The world is full of boys.

ZELDA: We didn't need to advertise or nothing.

RON: Wasn't necessary, was it Zel?

ZELDA: Word of mouth. Next thing we know there's a queue, dinner times – kids wanting to see her, for a consultation.

CHEWY: It's me reading, me words get all muddled up.

ZELDA: Dyslexic he was.

CHEWY: Can't read nothing, can't read – sodding – nothing.

RON: I got this cousin can't read.

CHEWY: But they take the mick, don't they? I just want to be normal.

RON: (*Scanning him.*) You get a pain in your head?

CHEWY: Yeah.

RON: Thought as much.

ZELDA: Saw a red light – coming out of his head.

RON: It ain't just – anatomical.

ZELDA: Words like that come to her, she didn't know where they come from.

Beat.

RON: You feel......sad?

CHEWY: I do feel sad.

RON: How long you been sad then?

CHEWY: Since me dad went off with that Laura.

RON: You got a hot water bottle at home?

CHEWY: Yeah.

RON: You put a hot water bottle on your heart twice a day – see if it shifts it.

CHEWY: You reckon?

ZELDA: Soon after that, he started reading…

CHEWY: (*Reading.*) 'Whether I shall turn out to be the hero of my own life, or whether that station will be held by anybody else, these pages must show…'

ZELDA: His dad, the one that run off with that Laura, he says Chewy must have been faking it all that time he couldn't read, but Ron's mum, she said…

MRS SHEEHAN: Miracle. Miracle it was. Something good come into our world, into our street. Finally, something really good.

Music.

ZELDA: Now, about that time, Billy Hammond's brother Lorenzo was a soldier, bombing Baghdad.

LORENZO: This is your brother Lorenzo here Billy mate, how's things back home in Smallville?

BILLY: That's what we called our town when Lorenzo wrote me letters but it wasn't small, it had 93,703 inhabitants. Things are A-OK – Lorenzo.

LORENZO: Good. Had a battle today and we won.

BILLY: Will you get a medal?

LORENZO: No. No medals as yet. How about you?

BILLY: No medals 'cause it isn't school games yet.

LORENZO: Right.

BILLY: School games are in July.

LORENZO: Alright mate. Signing off now, from the desert.

BILLY: Alright Zelda?

ZELDA: So so.

BILLY: Letter, from Lorenzo. Had sand in it, from the desert.

BILLY pours the sand out into his hand.

ZELDA: Oh yeah?

BILLY: There are four main categories of desert in the world, Sub Tropical, Cool Coastal, Cold Winter, and Polar.

Beat.

You seen those big girls up the Parade?

ZELDA: The Parade was where the shops was, near the school. You mean Rosie O'Donnell and that lot?

BILLY: Her brother nicked a car last night and drove it through the window of the dry cleaners down Aldergate Street.

ZELDA: Her brother Barry was a right head case.

BILLY: Say he might go to prison.

ZELDA: Anyway, next thing we know Chewy says that Rosie O'Donnell's brother wants like a confidential consultation. Ron had to think about it.

RON: The way I see it Zel, I ain't been given me healing abilities to pick and choose.

ZELDA: But it weren't easy because we didn't like Rosie O'Donnell or her mates and they never talked to none of us since we come here from primary.

RON: (*Decisive.*) I'll see him.

ZELDA: Next thing we know, he's sitting there, in front of us, down McDonalds.

BARRY: Alright?

ZELDA: Rosie and the others was outside, laughing.

BARRY: People was saying – you had a miracle – up your house.

RON: Yeah. That's right.

BARRY: And that you got these…special powers.

RON: Don't know what I got, but it seems to work.

BARRY: I remember you when you was…this weird kid from up the flats. Always had that plastic goldfish.

RON: What was it you wanted help with?

BARRY: This is stupid.

Beat.

I got done for nicking that car.

ZELDA: We heard.

BARRY: Does God – like – talk to you?

RON: No, nothing like that.

BARRY: But, you can do stuff?

ZELDA: He looked out the window at Rosie and those lanky girls she always hung out with.

RON: I'm more a channel me, for the energy.

BARRY: Me mum, she's sick. Bad she is. Said last night, after the Old Bill let me out, said I was killing her.

BARRY looks at RON.

But, thing is, I've always been this way.

RON: I'll scan you.

ZELDA: She did. He was in a right state. Thing about Barry was he was a real hard case, used to cut the names of his favourite goalies into his arms with a penknife. And half the other lads, they wanted to be just like him.

RON: You having bad dreams?

BARRY: How'd you know that?

RON: You got to find a dog. Make sure you don't nick it mind, and you got to look after it.

BARRY: You off your trolley? A dog?

RON: I can only tell you what comes to me.

BARRY: Find a dog?

RON: Come back in a month, tell me how you're getting on.

ZELDA: Now, when Ron was a baby, she was right strange, but her mum said…

MRS SHEEHAN: She's my girl and she's the nicest baby I've ever seen…

ZELDA: Her dad worked down Allingtons, in the office, the night Ron was born, all his mates was making this big fuss…

GINGER: Drinks are on you Trevor mate…

TROUSERS: Drinks are on the big man here…

GINGER: Wetting the baby's head…

TROUSERS: Say she's got a big head, that right Trev?

ZELDA: And she did have a right big head, but her mum said…

MRS SHEEHAN: That's for keeping her brains in.

ZELDA: So this day, about a month it was, after the miracle happened, we was in school like, and Ron gets called to the office.

MISS LOWERY: I've been hearing some things Veronica.

RON: What's that then Miss?

MISS LOWERY: I've been hearing that you have been promising… I'm not entirely sure what…promising to help people.

Beat.

Apparently something happened at home.

RON: Something come up through the floor.

MISS LOWERY: That's right. During the flood down the Dolbys.

RON: A supernatural occurrence.

MISS LOWERY: Veronica, a real supernatural occurrence must be verified, by…by experts.

RON: Why's that then?

MISS LOWERY: Because sometimes people get carried away, thinking that there is something happening which is not happening at all.

RON: Don't worry Miss, I'm only helping people who ask me. And I don't charge no money even though I could.

MISS LOWERY: But it isn't right, is it Veronica, to give people false hope?

RON: I don't do that Miss. I don't promise them nothing. Can I go now?

ZELDA: 'Bout that time loads of the grown ups got in a right state about it all, but the trouble with grown ups is they ain't really got the time to think things through properly, 'cause they're always worried about whether they can get a flat screen TV and a holiday in Crete in the same year, and whether they should put old people in homes, and whether being a single parent means you'll never get a bloke again and stopping the lad in the family nicking things, so they ain't really got the headspace to have much of an opinion about anything, but the long and the short of it was, they didn't like it. That was when we started to go undercover, 'cause, like Ron said…

RON: Better lie low for a bit…but, they way I see it, we do have a responsibility, to give something back, when you been made a custodian of such a gift.

ZELDA: Now I know what you're thinking – that I might have found myself being jealous of Ron, the miracle not having

come up through my floorboards, and then taking up the role of her – like – assistant, but, tell you the truth, I wasn't bothered. After she honed her skills, she started doing animals, which she said was 'naturally more receptive than people being more closely attuned to the universal'. Barry showed up with his dog…

BARRY: Found it round the back of the offy.

ZELDA: Horrible it was. Looked like a scrubbing brush with nasty little teeth up one end and a stump for a tail.

RON: What you called him?

BARRY: Maximus Decimus, after that bloke – in *Gladiator*. He doesn't half stink the house out.

RON: You got to clean him up.

BARRY: Why am I doing this?

RON: You got to clean him up and talk to him, he's scared.

ZELDA: She gave Maximus a scan.

RON: Used to live up North somewhere. Been on the road a long time, says he's hungry.

BARRY: I give him dog food, he ain't interested.

RON: Give it him on a spoon, come back to me in a week.

ZELDA: So Barry starts walking round with the dog stuffed up his jacket all the time and now and then he'd put it on the chair beside him down the caff and feed it baby food from a jar, with a spoon.

BARRY: (*Feeding the dog.*) Alright Max, there you go mate.

THE WALL DOWN THE SHOPS

ROSIE O'DONNELL, RONDA and RENATA-MAY, The Lanky Girls, are hanging out when BARRY comes by.

RONDA: That's your brother Rosie, with the dog.

ROSIE: (*Trying to keep her cool.*) Yeah, he's totally lost it.

RENATA: Anyone got a fag?

RONDA: Least he could've done was get a real bloke's dog. Bull terrier or something.

RENATA: I'm dying for a fag I am.

RONDA: (*Calling over.*) You ain't saying much Barry.

ROSIE: You finished showing me up yet?

BARRY: Just shut it, will ya?

RONDA: It speaks.

RENATA: Got any chewy?

ROSIE: Don't you never eat?

RENATA: I do eat. I eat chewing gum.

ROSIE: That ain't eating. It's CHEWING.

RONDA: You used to be such a laugh Barry.

RENATA: Remember when you smashed down the school wall and Miss Lowery shouted so loud there was like dribble coming out of her mouth. Gross!

ROSIE: There ain't no rule says you got to stand here, is there? I mean, there's a whole town all around us in case you hadn't noticed.

BARRY: You left Mum on her own.

RENATA: I really fancy a burger.

ROSIE: Yeah, like you have, for the last ten years. Don't you go telling me I got to stay home and look after Mum 'cause you ain't never done nothing for Mum, alright?

RONDA: Cheek. You hear him?

RENATA: Or a battered sausage.

BILLY arrives.

ROSIE: Here we go.

BILLY: (*To BARRY.*) Alright?

No one says anything.

You still got that dog?

Beat.

It's up your jacket.

Beat.

If I had a dog I'd call it Rex.

BARRY: Right.

BILLY: Which means King.

Beat.

I could walk him for you.

BARRY: He don't walk.

BARRY makes a roll up.

BILLY: He don't walk?

BARRY: Don't like it.

BILLY: Why doesn't he like walking?

BARRY: I don't know. He's a lazy bugger. He's only got little legs.

BILLY: You still stealing cars?

BARRY looks at BILLY. BILLY feels uncomfortable.

I got to go soon cause my brother's coming home.

BARRY: Oh yeah?

BILLY: He's bringing me a present.

BARRY: Great. Cool man.

BILLY: He's a soldier. Are you going to jail?

BARRY: I don't know. Maybe.

BILLY: I got to go.

BARRY: Yeah. Right.

BILLY goes. BARRY is left, the words resonating. He leaves. The girls watch him go.

Music.

LORENZO walks on, in uniform, carrying his kit bag.

ZELDA: First night Lorenzo Hammond come home from the war they had a drink for him down Squeaky Mary's in the Family Room…

SQUEAKY MARY'S

ZELDA: My mum, she was in a right mood…

MRS GINGER: Now you listen to me Veronica 'cause I ain't going to say this to you more than once. I want you to sit there nicely with Zel and BE NORMAL. I don't want to hear NOTHING about miracles or special powers or CONSULTATIONS. You can both have some crisps and be normal girls for one night, is that too much to ask?

ZELDA: Problem was, once you're given special powers you can't just turn them on and off like a tap, can you Ron?

RON: No way.

ZELDA: And when that Lorenzo come in, Ron was immediately affected by the terrible state of his auric field.

RON: Never seen nothing like it.

HEADER: Here's your pint son.

MRS HAMMOND: I never thought your dad and me, we'd see you home…

HEADER: Wait till he tells you about that Saddam's Palace…

MRS HAMMOND: That Saddam Hussein, he killed babies, isn't that right love? What kind of man would do that? Poison babies?

LORENZO: Alright Angela…how you been?

She looks at him.

GINGER: I want to thank you son, for what you did…

LORENZO: Alright?

GINGER: You acted for all of us out there, in all our names.

LORENZO: It was just a job.

GINGER: Just a job? See that? Modesty? What did I tell you?

LORENZO: (*To ANGELA.*) You want to get out of here?

She looks at him.

Dad, I was thinking, that I might not stay…

HEADER: But you can't go home son, the party's for you…

MRS HAMMOND: We got all the bunting out…

MRS GINGER: Last came out for the Silver Jubilee…

GINGER: What do the Royals know…

MRS GINGER: As I was saying…

GINGER: That Edward couldn't even get in the Marines…

LORENZO: (*To ANGELA.*) Don't go…

She looks at him.

MRS HAMMOND: Didn't they feed you out there?

LORENZO: How'd you mean?

MRS GINGER: He's skin and bone…

GINGER: Representing your country…

LORENZO: There were people there from all over…

GINGER: But the British Army, it's the best in the world…

HEADER: He needs another drink, the boy's glass is empty.

GINGER: Should have joined the Territorials…

TROUSERS: You what?

GINGER: I ain't too old, I should have joined up, could have
served out there – in Iraq.

TROUSERS: You're too old.

GINGER: No I ain't.

MRS GINGER: How d'you make it that you're fit to serve in the Territorials when you can't even put up a shelf?

GINGER: Don't be so stupid.

MRS GINGER: What's stupid about that?

GINGER: It ain't the same thing woman, is it? Serving your country and putting up sodding shelves.

MRS GINGER: There ain't no glory in putting up shelves…

GINGER: Glory? Glory? What do you know about glory…

ZELDA: And soon it was getting well out of hand, with my mum and dad having a right go at each other…

MRS GINGER: Nothing! I have to make do with the little things – the little victories, like making the beds…

GINGER: What you haven't got…

MRS GINGER: What haven't I got?

GINGER: What you haven't got is the size of a head that can entertain a concept like SERVICE…

MRS GINGER: God give me patience…

GINGER: What would you know of Patriotism…of CAMERADERIE…

MRS GINGER: What would you know of it, the nearest you've ever come to testing your character is watching *Full Metal Jacket* on the telly.

GINGER: I wouldn't shrink from my duty if I got the chance… I wasn't made for a life like this…

MRS GINGER: You wasn't made for any kind of life, you never get up off the sofa except to go down the pub…

GINGER: I'm sick of listening to you. Where's the boy? LORENZO? I want to hear it all, I want to talk to you – about the war.

LORENZO: (*To ZELDA and RON.*) Here we go…

BARRY comes in with MAXIMUS.

BARRY: Alright Lorenzo.

GINGER: You seen real action over there?

BARRY: Give us a pint…

MRS GINGER: It's only soft drinks for kids…

BARRY: Who're you calling a kid?

MRS GINGER: Trev you tell him…

TROUSERS: You heard her Barry…

MRS GINGER: And he's got that smelly dog stuffed up his jacket…

GINGER: You brought back any souvenirs?

LORENZO: Souvenirs?

GINGER: You can tell me – like one of them Republican Guard cap badges…

MRS GINGER: (*About BARRY.*) His mother, she's that poorly with cancer and what does he go and do? Steal cars? That's how he helps her out.

GINGER: That's what they did in the last war, nicked their helmets, brought 'em back, made flowerpots of them.

MRS GINGER: His mother might not live to see the New Year and what does he do? Steals cars.

ANGELA: Alright Barry?

BARRY: Thought you didn't talk to rubbish like me.

ANGELA: Must be feeling charitable.

BARRY: You still with that wanker Paul Fraser?

ANGELA: No. I dumped him.

BARRY: Thought it was the other way round.

ANGELA: You here with your girlfriend then or do you find it difficult to get off with girls while you got a dog stuffed up your jumper?

ANGELA walks off.

HEADER: Bit of hush. Alright, alright.

LORENZO: Dad…

HEADER: Now I know he doesn't want no fuss made but he deserves a proper welcome home…

Cheers.

'Cause a little bird's told me he was a credit to all of us over there…

GINGER: Well done Lorenzo lad…

MRS GINGER: Oh can't you ever stop…

GINGER: What?

HEADER: And I know it can't have been no holiday for you son, but we was with you every step of the way, so here's to you Lorenzo…

OTHERS: Speech! Speech!

ANGELA: Make you wish you were a hero coming home Barry?

BARRY: I wouldn't fight in their shitty war.

GINGER: Watch your mouth you!

BARRY: Who are you then, the talk police?

GINGER: You come outside and say that.

MRS GINGER: Oh Ginger, just let it go.

HEADER: Round of applause for Lorenzo, our hero.

Applause. LORENZO stands in the spotlight.

A huge silence. Discomfort grows.

LORENZO: Don't know what to say…

HEADER: Tell us what it was like son…

BILLY: It was hot, wasn't it Lorenzo?

LORENZO: Yeah. Hotter than the hottest day you ever get down Brighton…

GINGER: Wasn't no joyride, was it?

LORENZO: So, thanks for coming, and, have a good drink.

Suddenly LORENZO is finished. People start to clap, uncertainly.

LORENZO finds his way to ANGELA.

Give it ten minutes alright? Then we'll go.

LORENZO goes to talk to some of the others. BARRY approaches ANGELA.

BARRY: You've pulled then.

ANGELA: What's it to you?

BARRY: You always fancied him.

ANGELA: Maybe you've got it wrong. Maybe he always fancied me.

ZELDA: Must have been a week or so after that we was called into Miss Lowery's office one day, me and Ron, and our mums and dads was there two.

THE HEAD'S OFFICE

ZELDA, RON, MRS SHEEHAN, GINGER and MRS GINGER.

MISS LOWERY: It's been going on clandestinely.

GINGER: Talk straight woman.

MRS GINGER: Oh why can't you just listen for once?

GINGER: What's up with you now?

MISS LOWERY: Veronica is clearly the main influence.

ZELDA: She talked like I didn't even have a mind of me own – int that right Ron?

MISS LOWERY: She's been meeting people – in the toilets.

MRS SHEEHAN: Ron?

GINGER: What kind of people?

MISS LOWERY: She's been giving them advice, for their problems, suggesting treatments.

MRS SHEEHAN: Ever since the flood...

MISS LOWERY: I am aware what happened at your house Mrs Sheehan.

MRS SHEEHAN: It was – wonderful.

GINGER: Here we go. You told the Pope yet have you? Next thing we know she'll have a plaque over the door and it'll cost you a fiver to go in and take a look around the place.

MISS LOWERY: I understand some debris was washed up when the canal burst its banks.

MRS SHEEHAN: Veronica woke up with a statue of St Anthony in her bedroom. In the bottom bunk. I've always felt very close to St Anthony.

MISS LOWERY: I believe the entire contents of St Saviours was affected by the high rainfall that night.

MRS SHEEHAN: But to find St Anthony, in your bedroom... I mean – how did he get in?

GINGER: (*Sneering.*) Maybe he came down the chimney, like Santa Claus?

ZELDA: My dad always said stupid things like that, I mean, Ron didn't have a chimney in her bedroom, did she?

MISS LOWERY: There were all sorts of things washed around the streets that night, my own neighbour found her microwave stranded on the pedestrian crossing at the end of her road.

MRS SHEEHAN: But, that wasn't the case with us. We were virtually untouched by the storm. It's got to be an omen, at least.

GINGER: An omen? What planet are you living on woman?

MRS GINGER: He has no faith in anything.

GINGER: What are you asking me to have faith in, a bloody statue coming down the chimney?

ZELDA: It didn't come down the chimney!

MRS SHEEHAN: I mean, he wasn't even storm-damaged. He looked – pristine.

GINGER: Who did?

ZELDA: St Anthony!

MISS LOWERY: Veronica, have you anything you'd like to say?

Everyone looks at RON.

ZELDA: Thing is – she didn't. I mean, what was the point? See, our street, our town, it's full of things that used to be different, things that have got stuck, things that are like shells of themselves. From the top of our street you can see the roof of the old Mill, that's been empty for years and years…

GINGER: That was work. Jesus, that was work in those days. A man would break his back for his family in those days.

MRS GINGER: Fancy yourself do you, coming home on a Friday night? The man of the house. The lord and master?

GINGER: All I'm saying is…oh forget it. You wouldn't understand.

ZELDA: And up the road there's the school with the bell where they had to close it down after the First World War when all the boys went to fight and only two come back…

MRS SHEEHAN: That's the nun's school Ron, look, you can still see the apple trees the sisters planted before the war, and they had their own donkeys and every donkey was

called after a saint, and my granny remembers being given a ride on Bernadette and the donkey bit her and she went running into the Mother Superior crying that she'd been bitten on the bum by St Bernadette!

RON and MRS SHEEHAN laugh and laugh.

ZELDA: There's the place that used to be a snooker hall, and then they made it a gym and then a kick-boxing place and then a snooker hall again…there's the flats where the Irish lived, and then the Asians, and then the Turkish and then the Kurds…there's the house that used to be where old people went to die and then a residential care place for boys and then one of them clinics where you get needles stuck in you all over and then a sex shop…

MRS GINGER: Don't go near that place Zelda, you hear me? What did I say?

ZELDA: And there's the people, my dad who wanted to be a policeman but wasn't tall enough so he went to work in Bentley's, behind the counter, and Ron's mum who was going to emigrate to Australia and work on a sheep farm but her sister got sick and she had to stay at home, and then it was too late for her to go because she had a husband and baby…

MRS SHEEHAN: Everyone has their moment Ron, when their destiny comes right along and taps them on the shoulder, everyone has their moment.

ZELDA: There were people all through those streets with problems, and it seemed to me only Ron here wanted to help. So anyhow, they made us promise, that it was finished, and we wouldn't do it no more.

CHEWY: Ron, you got to talk to me.

ZELDA: She ain't allowed.

CHEWY: But it's an emergency.

RON and ZELDA stop, look around, scared they're being watched.

If you stop using your special powers, what's going to happen to me reading?

ZELDA: He had a point. Maybe if Ron packed it in, everything would start going backwards.

CHEWY: See – I can't go back to being thick.

ZELDA: You wasn't thick Chewy.

CHEWY: Whatever, but I can't go back.

ZELDA: And we was just starting to think about what our responsibilities was when Angela Brickman comes legging it in saying the Old Bill have only gone and picked up Barry O'Donnell for a car that he nicked down the Hollings, and his mum went mental, and Barry's come back and took his uncle Bill's machete and he's up the playing fields swinging it over his head and there's loads of police – course we only had one option, didn't we? We had to go, see what we could do to help out.

THE PLAYING FIELDS

PC 703: Come on now Barry, don't be a right wanker.

BARRY: I've told you, I'll top meself.

PC 703: With a machete? What you going to do, chop your own head off?

GINGER: What's all the noise?

TROUSERS: That kid what nicks all the cars…says he's going to top himself.

GINGER: (*Shouting.*) Get on with it then! Do us all a favour!

PC 703: I'm sorry kids, we've got a bit of a situation here, you can't come through.

ZELDA: Course it was all their fault the Old Bill, 'cause Barry never took that car at all, because he was turning over a new leaf, 'cause of his mum being poorly…

TROUSERS: Stop being such a stupid bugger Barry!

BARRY: I never touched no car and you ain't going to put me inside.

GINGER: Should throw away the key they should. All kids like you are doing is using up valuable oxygen.

BARRY: I want to talk to *her*.

ZELDA: Everyone turns, and he's pointing at Ron. I mean, what could she do? The way she saw it, it was her civic duty to help out,

BARRY: I never done it Ron. Look, I still got me dog, like you said. Why would I go nicking a car when I got me dog and me mum to look after?

ZELDA: Ron give him a quick scan…

RON: I believe him. You've got the wrong man.

ZELDA: The press was there and next thing we know Ron's on the front of the *Shopping Gazette*… 'Local girl at heart of police drama' but – like I said back then, Ron never sought no publicity…

RON: I never…

ZELDA: But, when you've got special powers it ain't easy, to keep things low profile.

MISS LOWERY'S OFFICE

MISS LOWERY: (*Examining the local paper.*) I'm very disturbed by this Veronica.

RON: I was only helping to avoid a miscarriage of justice Miss.

MISS LOWERY looks at her.

MISS LOWERY: I would ask you merely to think about this logically Veronica.

RON: Yes Miss.

MISS LOWERY: If God had decided to reveal himself through a miracle at this time in the world's history, why do you think we would choose to reveal himself to you?

RON: Don't know Miss.

MISS LOWERY: Re-acquainting myself with your long history at this school, I think it's only fair to say that you have not been without your challenges while you've been with us.

RON: In what way Miss?

MISS LOWERY: I am right in saying, am I not, that when you first came to us from primary you had problems making friends.

RON stares at her.

And it was felt necessary to see if you needed to be statemented for special needs.

RON: But I'm alright now Miss.

MISS LOWERY: What I'm trying to say Veronica is that, for a girl like you, an isolated girl, a girl who has problems fitting in, to be seen as some sort of – celebrity – it would have its advantages.

RON: But I'm not a celebrity Miss. I mean, I didn't ask to be given my special powers.

MISS LOWERY: What do your special powers feel like Veronica?

RON: It's hard to explain.

MISS LOWERY: A sense of excitement?

RON: I dunno.

MISS LOWERY: It is exciting, isn't it, to be important in people's lives, to have people needing you, thinking you're special?

RON: I dunno.

MISS LOWERY: We'd all enjoy that, wouldn't we, being so popular, being so – valued.

RON: I ain't doing no harm.

MISS LOWERY: But you are. You're giving people false hope. That's a terrible thing Veronica. And you're pretending you know things you can't know.

RON: But I do know them.

MISS LOWERY: No you don't Veronica. You cannot know whether a disease will heal or if a boy is innocent or how to help a child to read. Some of these things we can never know, others can only be deduced with the assistance of trained minds. Do you have a trained mind Veronica?

RON: No Miss.

MISS LOWERY: So if you have no appropriate training we must assume that the source of your knowledge is direct intervention from God. Do you consider yourself a religious person Veronica?

RON: I don't know Miss.

MISS LOWERY: So can you explain to me why, of all the wise, pure, gifted and spiritual people in the world, God would choose to reveal himself to you?

RON says nothing.

Peter you can come in now.

CHEWY comes in looking scared out of his wits.

Now Peter, I want you to tell Veronica what you told me earlier.

CHEWY looks at RON desperately.

I spoke with Peter and his mother at their home yesterday, and he has something he'd like to say to you.

CHEWY: I made it all up – that you helped me. I was always able to read. I was just pretending.

MISS LOWERY: So you see Veronica, you are just a normal girl, an ordinary girl, and being ordinary, it really isn't such a burden to bear, is it? We all have to struggle on knowing that we are most of us really very unremarkable. That's what growing up is all about.

ZELDA: I said she must have put Chewy in the slammer, beaten him up with electricity cables to make him say what he said but it turns out…

CHEWY: They never. My mum just started crying and said she couldn't take no trouble at the school, and that she just wanted everything to get back to normal and that if I didn't stop telling lies it would kill her 'cause her blood pressure was through the roof as it was and that second job she was doing down the Hollings would be the death of her and did I really think everything circulated round me? So I had to Ron. I had to say what they told me.

ZELDA: They put Barry in this foster place till his case was due to come up…he met Ron the day before, up by the old Garage on the roundabout.

BARRY: You better take me dog Ron.

RON: You was good with that dog.

BARRY: He's a right awkward bugger. If he wants to, you know, go outside, he looks at you.

BARRY hands RON the dog.

See you 'round.

He goes. RON is left holding the little scruffbag of a dog.

ZELDA: People started talking after that, 'cause, the whole miracle thing, it became this joke and no one wanted to look like they'd been taken in. Angela Brickman she was the first to kick off…

ANGELA: Yeah, that's right. I had a right laugh – went to her for 'advice'. And you know what she tells me to do? Eat pineapples!

ZELDA: Ron just looked at her, said nothing.

RONDA: You lost your 'special powers' Ron?

GINGER: I always said there was something wrong with that girl.

MRS GINGER: And you're the expert are you? You can tell the world what normality is?

GINGER: All I'm saying is, that girl's never been right.

ZELDA: Things were bad just then, with Barry in the halfway house, and Ron in trouble and being, I would say, sort of vilified, for simply trying to lend a helping hand, then over at Lorenzo's house things took a turn for the worse.

MRS HAMMOND: You've got to talk to him.

HEADER: I don't know what to say.

MRS HAMMOND: I can't do this any more on my own.

HEADER looks at her, gets his nerve up, turns to face LORENZO.

HEADER: Your mother…she thinks…

A beat.

We think, that you should come out of your room. Eh?

LORENZO looks at them.

Play a game of football. Get some air son.

LORENZO looks at them. HEADER look at his wife.

MRS HAMMOND: The corner shop, they said, there was some…mistake.

LORENZO: There wasn't no mistake. I took the biscuits.

MRS HAMMOND: Why would you take biscuits? We have biscuits. Were you hungry? You could tell me if you were hungry. You never eat anything as it is.

HEADER: Did you steal biscuits from Mr Shah's shop?

LORENZO: You know something, he used to have this sign in the window, when we was at school, only two kids at a time. Pompous git. Sits behind that counter, listening to that stupid radio…singing along to that stupid music…

HEADER: I'm not sure if I understand this…

LORENZO: He deserved it. Look…

LORENZO takes out the remains of the packet of biscuits and shoves one in his mouth, munching it, shocking his parents.

(*Through the food.*) Call the police.

HEADER: Are you ill?

LORENZO laughs.

MRS HAMMOND: Mr Shah's always been so nice to us.

LORENZO: What does a packet of biscuits matter?

HEADER: I don't believe I'm hearing this. You've stolen these biscuits – from the corner shop?

LORENZO: That doesn't matter. What do biscuits matter? Look at the world.

HEADER: What do you mean 'look at the world'?

LORENZO: Look at the world we're living in. What do biscuits matter?

ZELDA: A few nights after that, there was this massive row…

HEADER hammers on his son's door.

HEADER: Lorenzo, open this door. D'you hear me?

They wait.

MRS HAMMOND: Lorenzo, it's Mum.

HEADER: What's he doing in there?

MRS HAMMOND: Lorenzo! If you need the toilet, come out.

HEADER: What? Why are you saying that to him?

MRS HAMMOND: Don't go on at me …

HEADER: I'm not going on at you, I'm asking you a question.

MRS HAMMOND: He's started going to the toilet, in his room.

HEADER: In his room? What do you mean? 'In his room'?

MRS HAMMOND: In the wardrobe. He's not well.

HEADER: Not well? (*Yelling and hammering on the door.*) LORENZO, open this door!

LORENZO: Come on then! Come on!

MRS HAMMOND: Lorenzo, I'll send dad away…

HEADER: Send me away? Why would you send me away…

MRS HAMMOND: You frighten him…

HEADER: He's not a little boy any longer…

MRS HAMMOND: You've always frightened him.

HEADER: Don't be so stupid.

MRS HAMMOND: He only joined the army to get away from you.

HEADER: And if it hadn't been for me, he'd have settled for this, this, backwater…

MRS HAMMOND: It's all you. You're the one that wanted to get away, but you drove our son out of the house instead…

HEADER: I should have gone, I would have gone if anyone had ever encouraged me…

MRS HAMMOND: Always blaming others…

HEADER: I had to stay! What could I do, leave my mother in that house all alone? What kind of a man would that have made me?

MRS HAMMOND: Our child could have been killed, in the war…would that have made you happy? Maybe it would, all those stories to tell down the pub, all that sympathy…

HEADER stares at her, speechless.

Suddenly LORENZO comes out.

LORENZO: I'm going out.

MRS HAMMOND: Why don't you change your clothes?

LORENZO: I don't care about clothes. Do you? I don't.

*He goes, leaving them shaken to the core. The sound of traffic.
LORENZO and ANGELA BRICKMAN in a stolen car.*

(*Laughing.*) Out of our way you buggers!

ANGELA: You're mad you are.

LORENZO: You only just noticed?

They laugh.

ANGELA: I didn't know you had a car.

LORENZO: There's lots you don't know about me.

ANGELA: Man of mystery are you?

LORENZO: Come on, let's drive up the Maltings, it's quiet
there.

ANGELA: (*Looking at him.*) Alright.

ZELDA: The night Lorenzo took Angela Brickman up the
Maltings, Ron was coming home when she run into those
lanky girls.

RONDA: Watch out everyone, here comes the witch.

RON looks at them.

Do us a spell then Ron 'cause I've got this awful boil on
my bum.

RENATA: Anyone got any sweets?

ROSIE: (*To RON.*) You've gone and made my brother go mental
you have.

RONDA: He was mental before if you ask me.

RENATA: You got any money? We could go get a kebab.

ROSIE: That's what they used to say about you, wasn't it Ron? That you was mental.

RONDA: She had to have one of them special assistants to sit with her in class in case she did something.

RENATA: Miss Roberts. I liked her. Always had Maltesers in her pocket.

ROSIE: Everyone hated you at primary, didn't they Ron?

RONDA: I'd have topped meself if I'd have been you.

ROSIE: And now everyone knows, what you been doing, how pathetic you are, your life is going to be so bad girl. So so bad. I feel sorry for you. I really do.

AT THE MALTINGS

LORENZO sits with ANGELA.

ANGELA: Why'd you want to sit up here?

LORENZO: What's wrong with here?

ANGELA: Those lads from Raincroft come up here. They beat up a boy from the estate a few weeks ago. He lost an eye.

LORENZO: They won't touch us.

ANGELA: Why's that then? You going to take them on, all your own?

LORENZO looks at her.

LORENZO: Might do.

ANGELA: Oh yeah.

LORENZO: Might have a gun. Might have brought a gun back with me, from Iraq.

AT LORENZO'S HOUSE

HEADER: Military police, they're at the door.

MRS HAMMOND: Military police? Why?

HEADER: They say up Lorenzo's barracks, there's a gun missing.

AT THE MALTINGS

LORENZO: You got to go now Angela.

ANGELA: Why've you got a gun?

LORENZO: You've got to have a gun. How would you protect yourself if you didn't have a gun?

ANGELA: Let's go back, eh?

LORENZO: Got to always carry your gun.

ANGELA: What's the matter with you? Are you having me on?

LORENZO: What?

ANGELA: You're acting…funny.

ANGELA looks at him.

It's cold, let's go.

LORENZO: You go back.

ANGELA: On me own?

LORENZO: Yeah. You go back on your own.

ZELDA: That Angela was well fed up, had to walk four miles in her heels.

RONDA: Ohhhhhhh Angela, that's a blister. You want me to burst it, I've got a needle here somewhere…

ANGELA: No thanks.

RENATA: Didn't he take you for nothing to eat?

ANGELA: I don't want to talk about it.

RENATA: I would have got him to take me up the Taj Mahal. Had a chicken madras.

RONDA: Why'd he make you walk home?

RENATA: With pickles.

ANGELA: 'Cause he's lost it. Alright?

ZELDA: Ron could sense there was something up…

RON: That army boy, he needs help…

ZELDA: But when the police found him, there wasn't no gun…

HEADER: Of course there was no gun. My son, he's a hero. He's served his country. He was out there when you were all sitting at home on your backsides watching it on TV. Now you come here, accusing him…you make me sick.

ZELDA: Then one day, he was gone. They looked for him, but they couldn't find him nowhere. Looked all over. Lorenzo's dad, he was going mad. Sticking up pictures everywhere, with Lorenzo's picture on, sticking them on lamp-posts he was…

ANGELA: Like he was a lost cat or something.

RONDA: 'Have you seen my son?'

ZELDA: Picture of him sitting having his Christmas dinner, smiling.

RONDA: Paper hat on…

HEADER: I'm going out looking again.

MRS HAMMOND: Don't go.

HEADER: I'm going out. I have to go out.

ZELDA: And blow me if one night Mr Hammond didn't turn up at Ron's house.

HEADER: (*Awkward.*) Alright?

MRS SHEEHAN: I heard…about Lorenzo, I can't imagine.

HEADER: Is Ron in? I wondered, could I talk to her?

ZELDA: Like I said, Ron, she'd stopped seeing people, but this time, she made an exception.

HEADER: I can't find him. I've looked, I keep looking, but, I can't find him.

HEADER looks at RON.

Will you help me Ron? You can do it. I know. You can use your powers to find my son.

ZELDA: Ron had to think about it. She sent Mr Hammond home, said she'd stopped doing that kind of thing, but she knew, she could see, exactly what was just about to happen, and she had to decide if she was going to do something about it. Must have been a week after that, Ron went out late one night, she took a torch and her big overcoat, the one everyone laughed at. It was going to be the last time she ever used her gift. The town was quiet, on edge you might say, like deep down, everyone knew that something was going to happen.

CHEWY: It's my fault. Everyone's having a go at Ron now, because of me.

ELENA Z: Don't be silly Peter.

CHEWY: But it is. 'Cause I lied, didn't I? I lied, about her helping me.

GINGER: When we was kids, we used to go up the back of the town with Mr Rodgers, looking for bats.

ELENA Z: Peter, you take everything too seriously.

CHEWY: But I lied. I betrayed her. I've ruined everything.

GINGER: He'd meet us by the old school and give us each a metal torch, with a silver ring on it so you could hang it up after, and we'd lie with our backs against the rocks and wait for the bats to come…

MR RODGERS: See that boys, there they are…

GINGERS: Yes Sir…

MR. RODGERS: The world is full of mystery, things we can never hope to understand…

GINGERS: I like mysteries sir…

MR RODGERS: Never lose that appetite for knowledge boy, you stop asking questions of the world and you'll be a poor excuse for a man.

GINGER: I loved him, that teacher.

MRS GINGER: What's the matter with you now, are you drunk?

GINGER: Never mind.

ZELDA: Barry knew what was happening – he was in this foster place down Allingtons, emergency overnight stay it was, and he was in the toilet, looking out the window, knowing there was something going on…

GINGER, MRS GINGER, BARRY and CHEWY all look up into the night sky. RON meets BILLY HAMMOND. They're both bundled up against the cold.

RON: What you doing here Billy Hammond?

BILLY: (*Suspicious.*) Nothing.

ZELDA: It was Billy's thirteenth birthday. Ron knew Lorenzo wouldn't miss it.

LORENZO appears out of the dark, bedraggled, as if he's been sleeping rough.

LORENZO: What'd you bring her for?

BILLY: I didn't. She was just here.

They all stand in the cold night.

You got to come home, Mum's going mad.

LORENZO: I told you Billy mate, I can't go home no more.

BILLY: It's not fair. I'm stuck there, all on my own.

The people of the town look out across the black night-time horizon.

MRS SHEEHAN: I still think of the landscape of Australia, I see it shimmering, translucent in the heat – and those ancient

people, aboriginals, so close to the earth, and us, so close to…nothing.

BILLY, LORENZO and RON stare out across the town.

When I was thinking of going to Australia, I must have been pregnant with Ron – only – I didn't know that, did I? And I was looking – gazing – into those brochures – of Australia – those flat-topped mountains – a redness over everything, and the dreams I had such dreams – I had to wonder – if Ron was dreaming too.

RON: You go home now Billy, and don't tell no one that Lorenzo was here.

LORENZO: Do as she says, eh? Go home mate, it's late. Happy Birthday.

Reluctantly BILLY turns and goes. LORENZO stands, cold.

ZELDA: There was a river run down through the moor…

MRS SHEEHAN: Run all the way from the hills right down to the back of Bentleys, where it turned grey as it met the town…

The sound of hundreds of bats taking flight, flapping their leathery wings against the cold night air.

MR RODGERS: (*Pointing to the sky.*) See that boys, see the bats over the water…

BARRY: My dad took me up that river once, winter it was…

MRS SHEEHAN: Rivers have magic in them Ron…

BARRY: Where's the water come from dad?

BARRY'S DAD: What you mean 'where's it come from'? What sort of a of question is that?

BARRY: Don't matter.

MR RODGERS: People used to be baptised in rivers long ago boys, because of their cleansing properties.

GINGER: All the boys got in and swam, under the moon…

MR RODGERS: Careful boys, careful…and no ducking each other.

GINGER: Why don't you come in Sir?

MR RODGERS: Because it's my job to look after you.

GINGER: I remember him saying that.

MRS GINGER: My mother used to say there was something odd about that teacher.

GINGER: Why can't you leave me alone. Can you not even…I mean, what's it to you? My memories?

MRS GINGER: What's the matter with you now?

At the river, the girl and the young man stand in silence.

LORENZO: You've got a dog stuffed in your jumper.

RON: It's Barry O'Donnell's dog. They've put him in care but he never took that car.

LORENZO: I know – I did.

RON: (*Turning on him.*) And you let them think it was Barry?

LORENZO: They never come asking, did they?

RON: But they're going to do him for it.

LORENZO: You think it would make any difference if I put me hand up and took the rap? Barry O'Donnell's been nicking cars since he was twelve years old. He nicked his dad's car, and set fire to it. He nicked a bus off the Council and you're telling me he's like this innocent kid carrying the can for something I did?

RON: Still isn't right.

LORENZO: There ain't no right and wrong no more.

RON: How'd you mean?

LORENZO: There ain't no right and wrong.

The community of mothers, fathers, teachers and children stand gazing out across the town, each in their own world.

RON: Your dad's been looking for you.

LORENZO: Oh yeah?

RON: Come to see me. Asked me to help.

LORENZO: (*Laughing.*) That's a good one.

Beat.

When we was kids, if we ever went to a caff or for a pizza or something, he used to say 'Put Billy next to you so he won't make noises'. 'Cause Billy, he used to make these noises and all Dad cared about was people looking and what his mates would say.

They look out across the town.

RON: You know what tonight is? Midwinter.

LORENZO: Oh yeah?

RON: Midwinter night if you catch a fish in your hands in the river, you can make a wish and it has to come true.

MRS SHEEHAN: Don't you know that Ron? Everyone knows about Midwinter night.

LORENZO: You've lost it you have.

RON: That's why I come up here.

LORENZO: You're a right head case you are.

LORENZO looks at RON, realising he's said something he shouldn't have.

It's just something people say. It don't mean nothing.

They stand together for a moment, neither knowing what to say.

RON: This is the last night, that I'm using me powers. That's my wish, to be normal again. (*Beat.*) You can have my last consultation.

He looks at her, not knowing how to take her.

MRS SHEEHAN: Midwinter…the longest night.

MR RODGERS: You see that boys, the constellations. The light from the stars takes thousands of years to reach us – we are looking at the sky of ancient Rome, we are sharing the night with Caesar.

GINGER: You think they might have gone up the Moors?

MRS GINGER: Why would they have gone up the Moors?

LORENZO: (*Smelling the air.*) What is that? Is it petrol? Oil?

LORENZO and RON stand taking in the air.

HEADER: When they reached the desert, the oil wells were burning. Darkness never fell, because of the glow.

RON: It's just the smell of our town.

GINGER: Found some boy up Derby with that gun. Couldn't say why he took it.

MRS GINGER: Had that disease they get when they crack up.

GINGER: Some poor boy. He hid that gun in the baby's cot.

MRS GINGER: They shot boys with it in the First World War.

GINGER: Didn't do no harm, just hid it.

MRS GINGER: Shot Davey Barratt's Uncle Les.

GINGER: Said he felt safe with having it near.

MRS GINGER: Tied him to a telegraph pole. He was only sixteen.

Beat.

LORENZO: (*Looking down on the city, shivering.*) They're all down there Ron, Mum and Billy…Mr Shah in his corner shop, the lads will be going bowling just about now, Thursday, be heading up The Tilers for a pint…down the bowling alley, jackets off, shirtsleeves, looking at girls sideways, roll ups, then down to McAllens punching each other's arms, heading down McAllen's where the smell of deodorant and dry ice cuts through the strobes. Alright mate? Let's get fucking rat-arsed – past Lucy Cummings from sixth

form whose brother got killed in the backseat of a Ford Fiesta doing 90 when they was all off their heads...

LUCY: Alright Lorenzo?

LORENZO: Put him up a headstone that looked like a racing car, the grandmother paid with money she got from the Christmas Club...

GRAN: How can I have my Christmas when I know one of me grandchildren don't have no headstone? What's the point of Christmas with him laying up the cemetery in an unmarked grave?

LORENZO: Down the Hamlins...

RON: Rashida Perez in those shoes...

LORENZO: 'I got them for me modelling'

RON: 'You need good shoes'

LORENZO: See you in Paris losers!

RON: Lives up Frenton now, got a baby, called him...Claude

I'll scan you now.

They look at each other, LORENZO trying to work her out.

LORENZO stands there, watching RON, as she scans him.

You got trouble sleeping?

LORENZO looks at her, unsure what's happening.

LORENZO: Yeah.

She continues to scan him.

RON: You got to have a bath, take as many as you like...

LORENZO: A bath?

RON: Hold your breath and put your head right under...so it's like...

LORENZO: I know...

MRS HAMMOND: I used to feel him moving, inside me, I'd say– it's alright – everything's alright – Mum's here…

RON takes her shoes off.

RON: Best get in now…

LORENZO copies her, in a daze, they roll their trousers up.

GINGER: Reeds there was in that water, soft between the stones…

MISS LOWERY: I'm very concerned to hear that Veronica is missing…

ZELDA: You said some bad things to her Miss.

MISS LOWERY: What I might or might not have said to Veronica is of no concern to you Zelda.

ZELDA: It's a bad thing, to tell a person that what they had to give wasn't wanted.

MISS LOWERY: I'm sure I never said anything of the sort…

ZELDA: Thing is Miss, when they found electricity – they didn't know how it worked but no one said it was a bad thing when they saw all that light. And you know why that was, don't you Miss? It was because of having vision, which is seeing beyond the everyday. Truth is, nothing great would ever have been discovered if everyone went round using what they already knew as the yardstick. That would have buggered up Einstein and everyone in no time, and that's what you done with Ron. You went and killed her potential.

CHEWY: You said that? To Miss Lowery?

ZELDA: Felt I had to, least I could do.

RON and LORENZO walk slowly, unsteadily through the water.

ZELDA: Someone said when they got up the Moors, Ron and Lorenzo, the boy that come back from the war, they was standing, in the river…

GINGER: Moon come up as bright as anything…

TROUSERS: (*Calling.*) Ron! Lorenzo!

HEADER: Lorenzo! Son!

GINGER: They're in the river!

MRS SHEEHAN: (*Spellbound.*) Oh Ron! Midwinter night!

The whole 'town' looks up.

BARRY: I want to change things – make 'em better, but I just keep being pulled back in, I dunno, I'm fifteen now, maybe it's too late, for a second chance.

ELENA Z: Go to sleep love.

CHEWY: I can't. I keep thinking, about what I said, about Ron, she was the only one who helped me…

ELENA Z: Didn't your dad or me, didn't we help you?

CHEWY: I just wanted to read good so they'd stop calling me names…

ELENA Z: You'll be alright love…

CHEWY: But what if we all get killed by something, what if all the water gets poisoned and we're forced to eat GM food and we get diseases and the terrorists come and get us…

ELENA Z: They're not coming tonight, I promise. No one's coming tonight. Now go to sleep.

GINGER: (*Calling.*) Ron! Lorenzo!

LORENZO and RON stand in the water, waiting.

(*Excited.*) Wouldn't it be something, to get a second chance…

MRS GINGER: What's the use in asking something like that?

GINGER: To start all over, with a will to do it better, to use what's been learned from life and still have time to put things right…

LORENZO stands in the river shivering.

RON: It's cold.

LORENZO:(*Moving away.*) I like it. We could swim…

RON: I don't know…

LORENZO: I was good at swimming… Not as good as Billy…

LORENZO takes a few unsteady steps.

RON: It's dark, you got to be careful…

LORENZO: But here…the water's that clean…cleaner than the swimming baths, eh Billy… Danny Williams always used to shit in those baths…

LORENZO moves further away.

And when you dived in, it all went…it all went…so… quiet…

Suddenly LORENZO disappears into the darkness of the water. RON stands there terrified, the silver torch in her hand.

HEADER: Lorenzo? Son?

All across the town, everyone closes their eyes – GINGER, MRS GINGER, TROUSERS, ANGELA, CHEWY, CHEWY's MUM, BILLY, HEADER HAMMOND, MRS HAMMOND, MISS LOWERY, BARRY, THE LANKY GIRLS…time stands still.

Far away, BILLY turns to look.

BILLY: It's nice under the water, isn't it Lorenzo? I can do a width now which is why I've got a badge. It's got a dolphin on it. See…

RON stands there, her terror rising, the torch shaking in her hand…

A long beat, silence, until…

Suddenly LORENZO rises out of the darkness, immediately before RON, with a great fish in his hands. They stare at each other in disbelief. She reaches out and touches it for one brief moment before it leaps back into the water. They stand there looking at each other.

ZELDA: When Ron and Lorenzo come home that night, they were changed…

RON and LORENZO join the rest of the community, standing, under the night sky, as at the start of the play.

They didn't talk about it, but Ron, she never used her powers again. She was thirteen that year, she joined the drama group at school, boys started to notice her, sometimes people would laugh and say 'Don't you remember Ron, you used to be such a weirdo' and she'd just smile. And Lorenzo, he got married, to that Rashida Perez...

LORENZO stands holding a baby in his arms.

LORENZO: Got a wife now Ron, and a baby.

RON and LORENZO look at each other.

RON: That's good.

LORENZO: We're moving away. Making a new start. Billy's going to come, weekends.

They look at each other.

Like a wish come true it is.

RON smiles at him.

ROSIE: What's he doing going off with that Rashida Perez?

RENATA: Anyone fancy some chicken nuggets?

RONDA: Someone told me that he'd taken her to Paris, for the weekend...

ANGELA: Shut up Ronda.

RONDA: But it don't make no sense.

ROSIE: And he's taken on that baby. That funny little baby, Claude. What'd he want with a baby that ain't even his own?

RONDA: I heard he bought her shoes, in Paris. Carried that baby all over he did, in a rucksack, on his back.

ZELDA: Ron's mum, she sent St Anthony back to the church. Wrapped him up in a blanket and popped him in the wheelbarrow...

MRS SHEEHAN: Don't seem right pushing a saint through the streets in a wheelbarrow...

MRS GINGER: Probably likes it Gail, probably having the time of his life...

ZELDA: Lorenzo told the Old Bill Barry never nicked that car and Barry went home to look after his mum, got the dog back and all, something had happened to him, no one knew what, but, he was good after that...

BARRY: I've made you scrambled eggs Mum. You eat something, eh? Make you better.

ZELDA: Chewy wrote a story that got published in a magazine. He gave it to Ron, said it would never have happened without her.

ZELDA stands looking out across the town.

What you reckon happened here Ron? What d'you think this was all about?

RON: Don't suppose we'll ever know Zel. Maybe it ain't for us to know. Maybe with something like this, you just got to take it....

...like a gift.

RON, ZELDA and the community look out across their town. LORENZO holds the baby.

The End

THE MIRACLE
TEACHING NOTES

WRITING THE PLAY

by Lin Coghlan

I am writing this as we near the end of the first week of rehearsals on *The Miracle*. I'm making discoveries about what I've written and perhaps why I've written it. When I started work on the script all I knew was that the Connections project at the National Theatre wanted me to write a big play, a play with a large cast for young people to perform themselves. It was as open as that. Most of the time when a theatre commissions a play they ask you to write a play with a *small* cast – even five can be considered too many – because having more actors for a run of several weeks means needing a bigger budget and every theatre has to think about the implications of this. So as a writer, being asked to write for a large cast is very unusual, and I wasn't sure how it would work out.

One of the things I was most worried about was that there would be some small parts which wouldn't feel very satisfying to the actor allocated that role, I didn't want that to happen, I wanted all of the characters to feel three-dimensional and important to the story, with their own life which should feel as if it extended beyond the life of the play. On the first day of rehearsals, the director Paul Miller said, 'Do you realise there are people in the cast list who don't speak and people in the play who speak who aren't in the cast list?' I hadn't. I just set about trying to create a community and see what might happen and each of the characters seemed to appear just when I needed them.

Most of the time I tell people that writing is all about working and thinking and plotting and planning. Inspiration doesn't show up very often and the process relies almost entirely on getting on with it. You do the work – and with a bit of luck the inspiration might come along as an added bonus. But just occasionally a play pops out fully-formed and you sit back and watch it appear on your computer screen or your notebook as if it was always out there somewhere just waiting for someone to come along and write it down. It's happened like this just a few times for me, and *The Miracle* was one of them.

I began one day in my back garden in South London (I never write in the garden) and I decided to have fun and tell myself the story. So I started as the play starts, 'No one believed us, said we was making it all up, but we never – int that right Ron?' I set off following the characters and seeing what they would tell me, and for the next several weeks each day I spent some time with Ron and Zelda, watching the world of the play as it began to come into focus.

I didn't know what the story was going to be about. I wasn't sure who was the central character or if there even was one, and I had no idea how it would end. As the community started to emerge I began to realise that everyone was longing for something in the play, missed chances, the past, change, and I wondered if Ron really had 'special powers' or if it was all in her mind? I wrote the play in exactly the order you find it here in the text, so when Lorenzo arrived back from the war I had no idea what impact he was going to have on Ron's story or that his relationship with Ron and her effect on his life would become the spine of the play.

When I reached the part where Lorenzo takes Angela Brickman up to the Maltings in a stolen car I had to break off for several weeks as I had another play going into rehearsal and I needed to think about that. I started to worry because I didn't know where *The Miracle* was going and I didn't want it to become a play about a soldier who steals a gun and somehow goes off the rails – that didn't seem the right way to go. It was quite a while before I could return to the play and I worried that I would have lost momentum and I wouldn't be able to get back into the strange world I'd created. But there was no problem.

By the time I sat down again, I knew that Lorenzo and Ron must meet on the moors, that somehow they were kindred spirits, but that the climax of the play must revolve around them.

The 'magic' in the play remains ambiguous. Every time Ron helps someone it can be interpreted a number of ways – that's how I wanted it to be. If I made it more defined I felt a whole sector of the audience would feel unable to relate to the story, because of having to wrestle with their own ideas about healing, spirituality and change. It's fine by me if people are not sure quite

how it was that Ron affected people when she decided to 'help' them, what matters is that she decided to act – and in so doing she set off a chain of events which impacted in all sorts of ways on other people's lives. I think we live in the most extraordinary times. Ours is the generation which has finally seen science and unexplained spiritual and paranormal phenomena meet; suddenly we can actually observe our own structure at an atomic level, seeing proven for the first time that we are all essentially fields of energy – ideas dismissed as mumbo-jumbo even twenty years ago now seem tantalisingly close to our scientific grasp. One thing is for certain, we are all of us more mysterious and potentially more powerful than we can possibly imagine, and as Zelda says to Miss Lowery, to judge things solely by the yardstick of that which we already understand is short-sighted to say the least.

The Miracle is about people having the nerve to reach out and grasp a second chance, and it is Ron's indomitable instinct to do something which turns out to be the catalyst for more than she might ever have imagined. I feel she would have very much approved of Goethe's take on things:

'Whatever you think you can do or believe you can do, begin it. Action has magic, grace and power in it.'

DRAMA AND WRITING EXERCISES

When I write, I develop both characters and story by continually asking myself questions. Questions about a character's motives, their past, their hopes, secrets and dreams. I try to imagine what happened to them before the life of the play and how things might turn out for them after the play ends. I am including here a number of exploratory exercises which might be useful to anyone interested in writing themselves, or for drama and school groups who might like to work on the play or create their own text or improvisations using the play as a starting point.

EXERCISES

In the play there are at least two generations of characters who have much in common, although they don't immediately realise it.

Ginger

When Ginger goes up on the moors searching for Ron and Lorenzo he remembers the school outings he used to take with his teacher Mr Roberts searching for bats.

- What do you imagine Ginger was like as a child?

- Write an account in Ginger's diary when he was twelve or thirteen, recording some research he might have done on the wildlife where he lived.

- Does this change the way you've thought about Ginger in the play?

- Could this material be developed into a scene, or a moment in the play where Ginger tries to share this memory with another character? Who might that be?

- Towards the end of the play Ginger wonders aloud about what it might be like to have a second chance at your life. How do you think he feels about how his life and how it's turned out?

- Ginger is one of the neighbours who is most excited to greet Lorenzo when he comes home from Iraq. He speaks of ideas like comradeship and service. Why do you think he feels so strongly about these qualities?

- Why do you think Ginger never decided to become a soldier himself?

- Why might Ginger not have taken that opportunity had it been offered to him?

Mrs Ginger

Mrs Ginger explains to her husband that what she is interested in is 'the little victories, like making the beds'. She seems to be a very practical person, who finds it difficult to relate to her husband's ideas.

- Why do you think practicality has become the most important thing in Mrs Ginger's life?

- What do you imagine Mrs Ginger was like when she was younger, say 16 or 17?

- What do you think Mrs Ginger and Ginger had in common when they first met which drew them together?

- Why has that changed?

Ron

We learn that Ron used to be 'an isolated girl'. We're told that at one time she always had a plastic goldfish, and that she also had a coat which 'everyone laughed at'.

- Do you think that Ron is aware that people see her as being 'different'?

- How do you think she feels about that?

- What strategies do you think Ron might have developed to protect herself from being seen as strange?

- If you knew Ron, would you be inclined to advise her to try and fit in or would you encourage her to be herself?

- Imagine you are Ron as an adult, looking back on that winter when the miracle happened. How do you think she would view the events after the passing of many years?

- Do you imagine there would be a difference in how Ron would interpret the miracle many years later or not? If there is a difference, why do you imagine her opinion might have changed?

Barry

- Why do you think that Ron advises Barry to get a dog?

- Why do you think he goes along with the idea?

- Barry has quite a reputation where he lives with a history of stealing cars, joyriding and anti-social behaviour.

- What might be an explanation for Barry's behaviour?

- What do you think he was like when he was nine or ten?

- Imagine you're writing a speech for Barry to give before his class in school when he was nine years old about his hopes and dreams, what might be on his list of things he wanted to see and do?

- After you've written the speech how do you feel about Barry now and how things have turned out for him? Have your feelings changed in any way? Why?

Lorenzo

Lorenzo returns from the war and he is still aged only eighteen.

- What do you think his expectations of the army might have been before he joined up?

- Lorenzo has a very close relationship with his brother Billy. Why do you think they are so close?

- What strengths and qualities to you think they have to offer each other?

- When Lorenzo goes to his welcome home party at Squeaky Mary's and is asked to make a speech he chooses to say nothing – and throughout the play he never says anything directly about his experiences in the war.

- Why do you think he has chosen not to speak about the war?

- Imagine Lorenzo decided to write to Billy on the flight home from Iraq. He wrote about his hopes and fears at returning home, but before the plane landed he tore up the letter. What might he have said? Is it possible he surprised even himself with what he wrote?

- When Lorenzo steals the biscuits from Mr Shah's shop he says to his parents 'What do biscuits matter?' and towards the end of the play, at the river he says to Ron 'There ain't no right and wrong no more'. What do you think he means by this?

- What gives a person their sense of 'right and wrong'? Can that change? What might influence a person to change their idea about right and wrong?

- Have you ever held a strong opinion about something and then had you mind changed about it? How did it happen?

- Are concepts of right and wrong concrete and defined or are they less defined and changeable? Look for examples of ethical issues where concepts of right and wrong seem to shift and change. How do we define our own ideas about what we think and believe?

- If Ron hadn't found Lorenzo at the river that night what might have happened to him? Many ex-servicemen struggle with making a life after they leave the services. Why do you think that is?

- Imagine it's ten years on from the end of the play and Lorenzo is now 28. In this version of the story Ron decided not to go to the river to find Lorenzo. Decide what might have happened to him. Write a scene from a play where Lorenzo meets Billy ten years later. Write a version where Lorenzo wants to talk to Billy about what's happened to him and why he left, then re-write it so that all of Lorenzo's feelings and what he needs to say is in the sub-text and unspoken. Read both versions of the scene aloud, explore the possibilities of each version.

- Write a newspaper account of Lorenzo's fate. Share the different versions of Lorenzo's life with the group.

Zelda

Zelda is a girl of strong opinions, yet as she says herself, it was not a problem for her to take on the role of Ron's assistant.

- How well do you think Zelda 'fitted in' with friends and classmates before she teamed up with Ron?

- Zelda never appears to question the credibility of Ron's 'special powers'? Why do you think that is? Do you think that Zelda believes in Ron's 'gift'? Is it possible that Zelda might have any other 'take' on what Ron is doing? What might it be?

- Zelda confronts Miss Lowery on having tried to 'crush Ron's potential'. Do you think she's right and that's what Miss Lowery did? Do you think Miss Lowery sees it differently?

Miss Lowery

- Imagine you're Miss Lowery confronted by this situation in the school. What might be her concerns? Do you think she is genuinely trying to help Ron and Zelda?

- Write a monologue for Miss Lowery on the night that Ron and Lorenzo are lost on the moors. What might be her private feelings about what's happened that she dare not share with anyone else? Although she's convinced in the play that she has acted logically and responsibly, does she have any doubts that she cannot even explain to herself? What might they be? Re-write the river scene but allow Miss Lowery to be there, sensing what's happening between Lorenzo and Ron and being able to speak alongside the rest of the community – what might she say?

- Imagine what Miss Lowery was like when she was Ron's age. Do you think she was different or a smaller version of her grown-up self? Why?

A PLAY WITHIN A PLAY – DRAMA EXERCISES

- Imagine that the play, *The Miracle*, is the back-story to a completely new play. Decide in pairs or small groups when this new play might begin.

- How many years later does the action take place?

- Which of the original characters will be in the play?

- How will their lives have changed?

- Will any new characters be part of the story?

- Rashida Perez's son Claude for instance might be fifteen years old. How might such a story begin? Perhaps it is Midwinter night.

IMPROVISATIONS

- Divide the group into performers and writers. (These roles may be swapped around so that everyone gets a chance at being both actor and writer.)

- The performers in pairs/small groups will create an improvisation to begin the new play, each deciding in their group who is key to the story and what will happen and where the action will take place. Perhaps Ron, a grown woman now, is revisiting the river where she is met by Rashida Perez's son Claude, who has something important to tell her. View the improvisations in turn, with the writers noting useful ideas, structures and dialogue/speeches.

- Swap around and improvise a key scene later in the play building on what the first group created. Perhaps Ron walks back through the town armed with the information Claude has given her and goes to confront Ginger or Miss Lowery or Billy Hammond. What might happen? Who would be central to the scene?

- Now that some free-flowing creative work has been done, stop to consider who might be the central character of this new play. How would the story feel if it were told from one, two or several points of view?

- Using the original text, identify a character who says little or nothing but is present in *The Miracle*. Taking such a character as Rashida Perez or Lucy Cummings or Chewy Zapadski's father, give them a voice and allow them into a scene either writing or improvising what they wanted to say about what happened on the night of *The Miracle*.

- What is the potential of bringing the minor characters to the fore of the story and allowing them a voice in a play set in the future?

- Having chosen some key characters, write a passionate statement for each one, then re-write it admitting that the first version was not the whole truth. Explore the potential of this exercise as a way to access inner conflict in the character's life.

MINING THE BACK-STORY OF THE PLAY FOR NEW MATERIAL

Pick an incident in the back-story of *The Miracle*. It might be the night of Ron's birth when her father, Ginger and Trousers were celebrating in the pub – or perhaps the day Barry O'Donnell drove a stolen car into the school gates, or the day Lucy Cummings' brother was killed in a car accident. Work out which of the original characters might have been there, what their ages would have been, what the heart of this new story might be, and how it might develop.